P9-BZQ-414

# GOOSEBERRY

## NADINE BLACKLOCK

## CRAIG BLACKLOCK

# GOOSEBERRY

## NADINE BLACKLOCK

## CRAIG BLACKLOCK

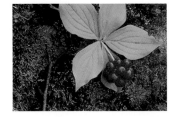

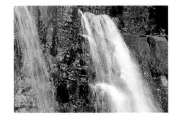

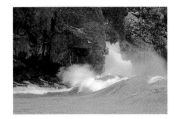

Pfeifer-Hamilton
Duluth Minnesota

**Pfeifer-Hamilton Publishers**
210 West Michigan
Duluth MN 55802-1908
218-727-0500

*Gooseberry*

© 1994 by Craig and Nadine Blacklock. All rights reserved. Except for short excerpts
for review purposes, no part of this book may be reproduced or transmitted
in any form by any means, electronic or mechanical, including photocopying,
without permission in writing from the publisher.

Printed in the Republic of Korea by Dong-A Publishing & Printing Co. Ltd.
10 9 8 7 6 5 4 3 2

Editorial Director: Susan Gustafson
Manuscript Editor: Tony Dierckins
Art Director: Joy Morgan Dey

Library of Congress Cataloging in Publication Data
94-29105

ISBN 1-57025-024-3

# Photographers Statement

Powerful images greet visitors as they enter Gooseberry Falls State Park. A prominent waterfall lies upstream from the bridge; downstream, in the distance, Lake Superior stretches to the horizon. Often these immediate views are all visitors take time to see. Most people first observe the park in a literal way, taking in the postcard-familiar views as they walk the well-marked trails. Only gradually do they gain confidence to seek more than the obvious.

Like first-time visitors to a park, pioneering nature photographers followed trails to grand vistas. They presented these scenes objectively. Photographers then started to capture details and abstracts, interpreting the natural world with the eyes of artists. Viewers could look deeper into these photographs and feel more connected to them.

We, too, create photographs to satisfy our personal vision. Yet we expect, and are pleased, that viewers respond from their *own* perspective to the patterns, shapes, lines, and colors in our images. In a close-up photograph of a waterfall, for instance, the textures and colors may be a metaphor for tranquility or turmoil, they may seem like gauze or ice, they may appear ordered or chaotic, or they may simply remind you of a visit to a waterfall and how the spray felt on your face.

Although our photographs speak first of place—in this book, specifically of Gooseberry Falls State Park—we hope you will find that they reach deep into your own heart. If so, we will have achieved our goal, communicating the essence of the river, the woods, the waterfalls, and the shore.

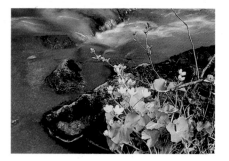

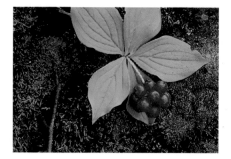

# River

# Woods

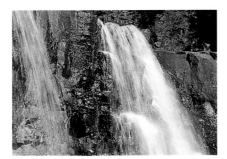

# Waterfalls

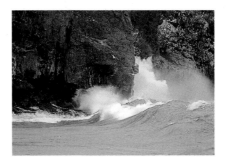

# Shore

The Gooseberry River originates in the Superior National Forest. Upstream, it is fairly narrow. Boulders, rapids, and waterfalls preclude any kind of boating. Downstream, below the waterfalls, the river charts a calmer course. Its banks are lined with tall grasses—perfect haven for ducks and beaver. Pebbles form the beach where the river flows into Lake Superior, and the shallow river mouth is perfect for summertime wading.

The riverside trails are good places to catch sight of deer. You can often watch them watching you before they slip silently into the woods. Chipmunks, squirrels, and mice might scurry by if you sit still for a time. Robins sing in the treetops. Gulls circle high above, screeching. If you are careful, you can wade in the current and watch a piece of birch bark float through a mosaic of pine and balsam needles. Then pick a spot on smooth bedrock for a picnic lunch and lose yourself in the river's kaleidoscope, watching the water fracture clouds, trees, leaves, and flowers into oscillating abstracts.

# River

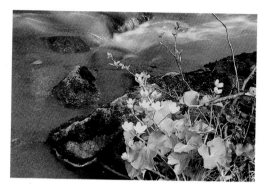

In winter, the moving pictures become static. Tracks in the snow tell many stories. You can follow the stitch-like tracks of a mouse to the spot where an owl snatched it, or examine the zigzagging steps of wolves around a deer carcass on the frozen river. A closer look reveals marks of smaller animals and birds that shared in the feast.

On a still January day deep snow dampens the river's music. The whoosh of a raven's flight draws your eyes to the sky. A slight breeze wafting through balsam boughs sifts snow to the ground. Over the rasp of your own breath and muffled footsteps, you hear in the distance the scrape of cross-country skis and a woodpecker jackhammering a snag.

Come spring, the cracking and crashing of ice replaces the quiet of winter. When the rush of water ebbs, the muddy shoreline is quickly inscribed with tracks of deer, birds, squirrels, and mice. Fresh sedges push up through last year's brown, tangled mat. Black flies and mosquitoes may distract you from contemplating the newly quiet, humming water. Their drone, however, cannot pull your eyes from bright marsh marigolds and equisetum, nor can it keep the satiny swish of new leaves turning in the breeze from reaching your ears.

Once you've scouted the inland parts of the river, make your way to the spot where the river meets the lake. Here thousands of pebbles are pushed around by waves, rolling and rattling like so many marbles. Before you leave, join others in a timeless game—see how far out in the lake you can skip some of the flatter stones, sending your cares away with their flight.

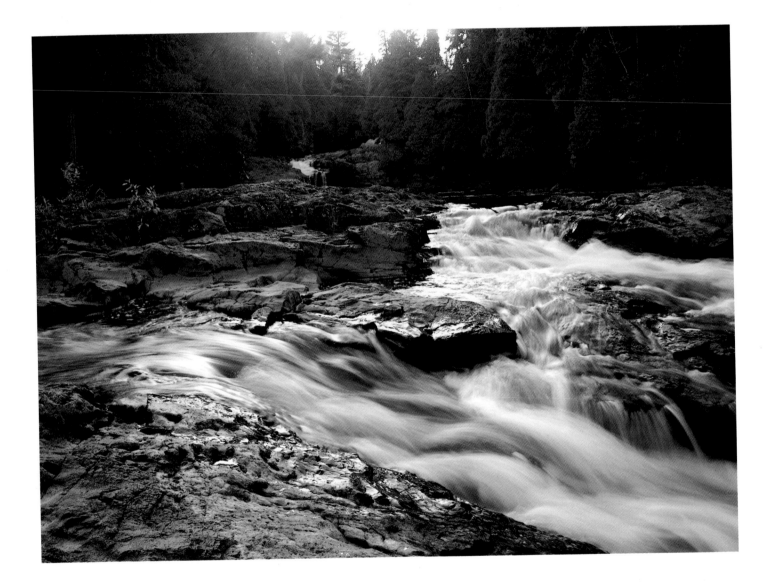

Downstream from Fifth Falls

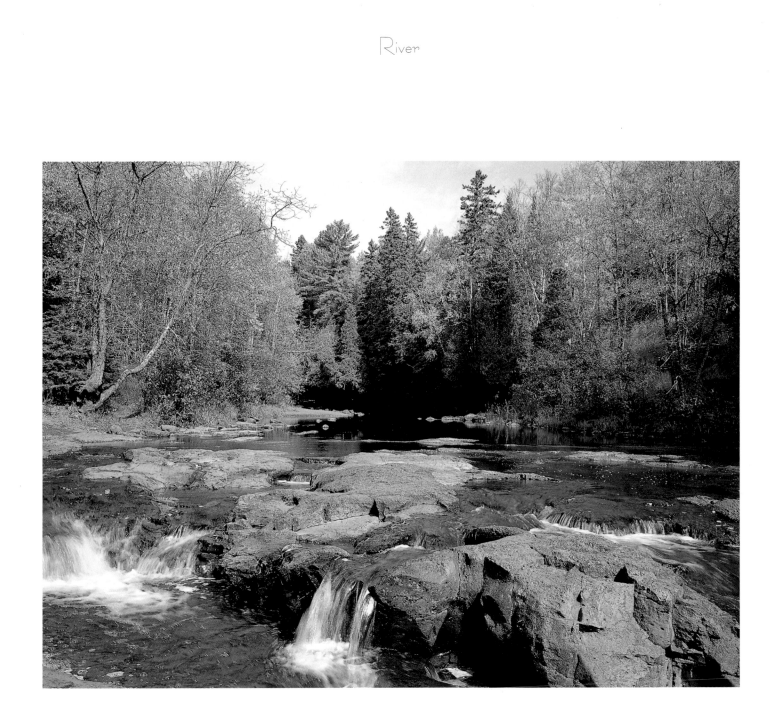

Above Upper Falls

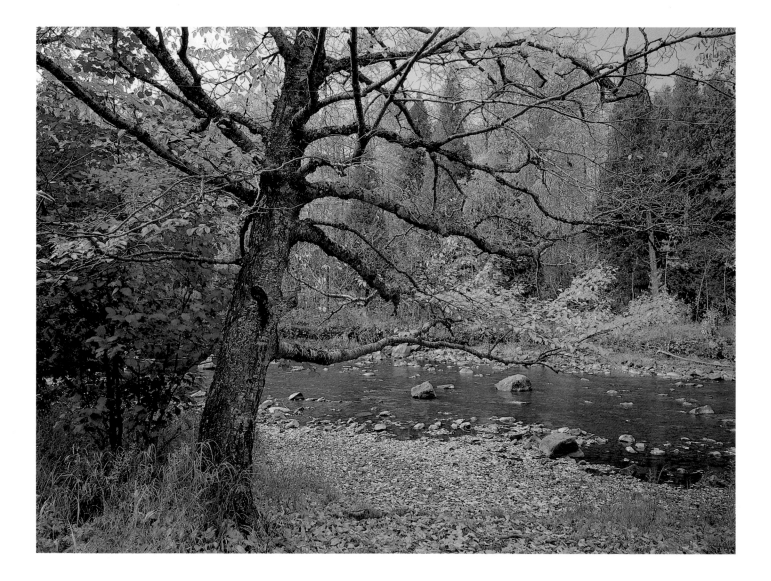

Birch tree

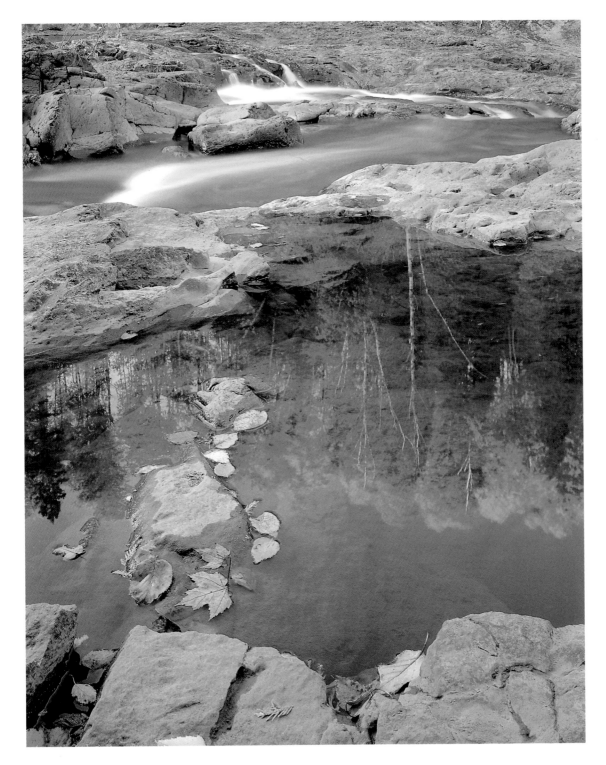

Downstream from Fifth Falls

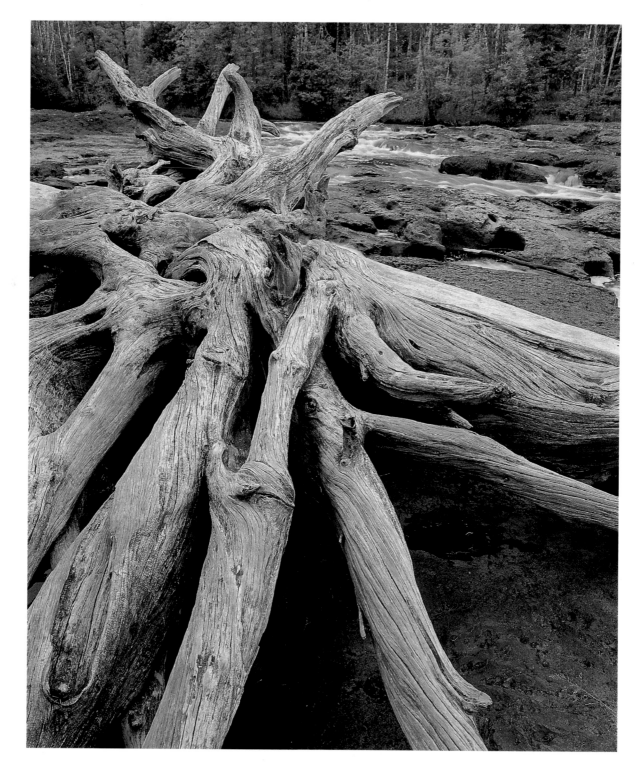

Weathered tree root

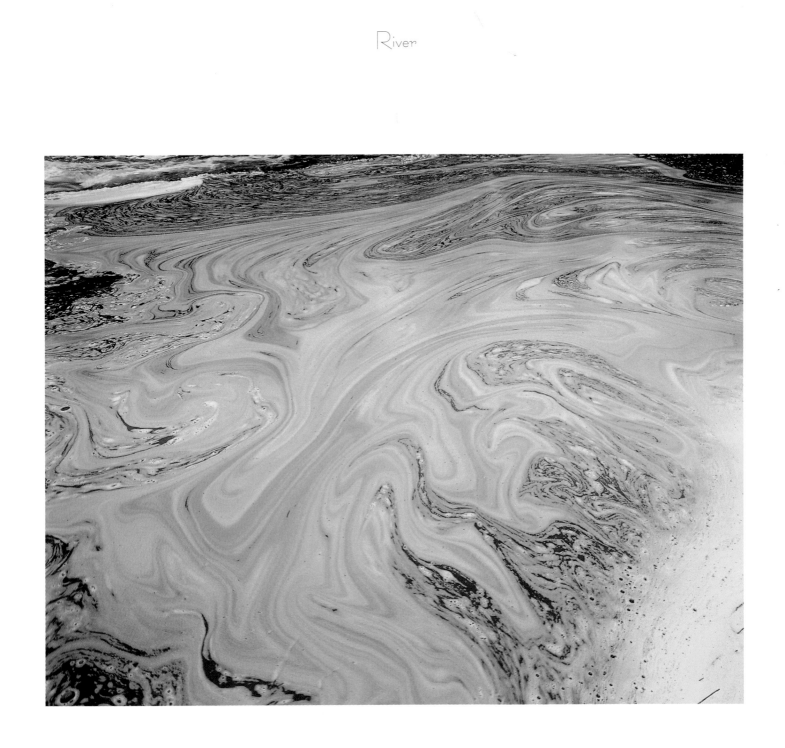

Foam patterns

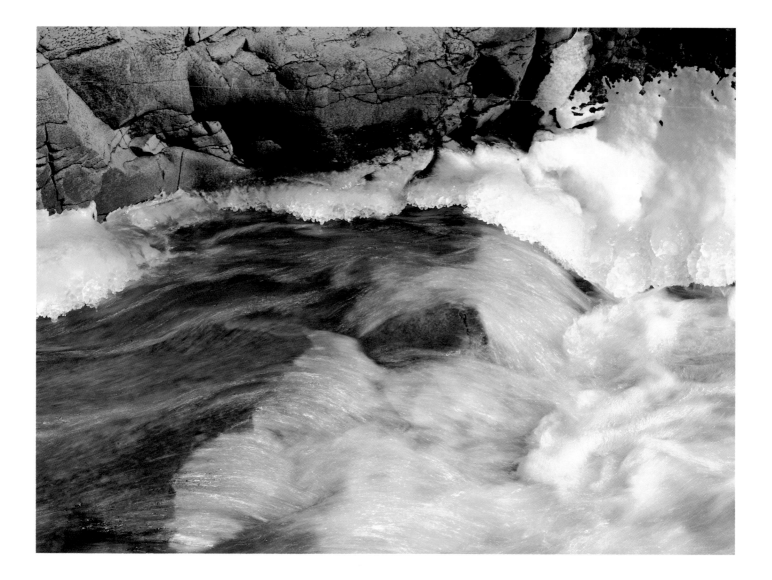

Ice below Lower Falls

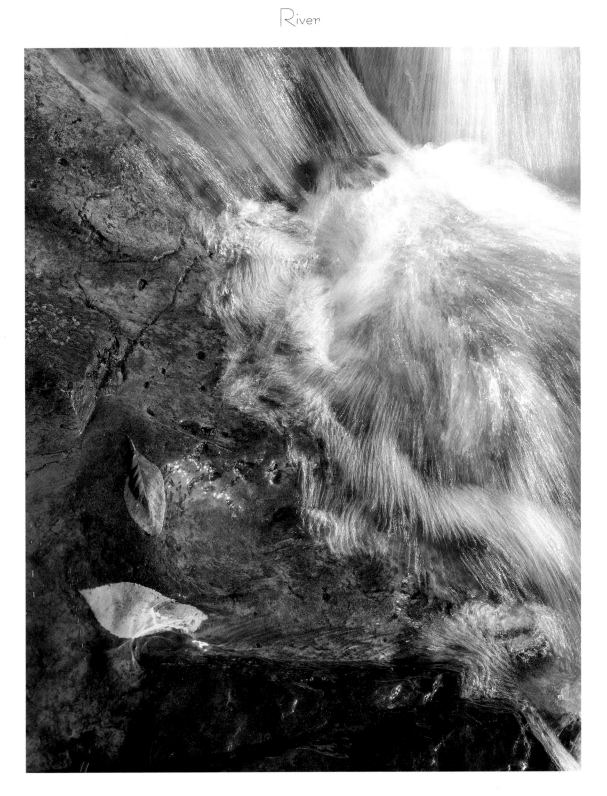

Above Upper Falls

Gooseberry

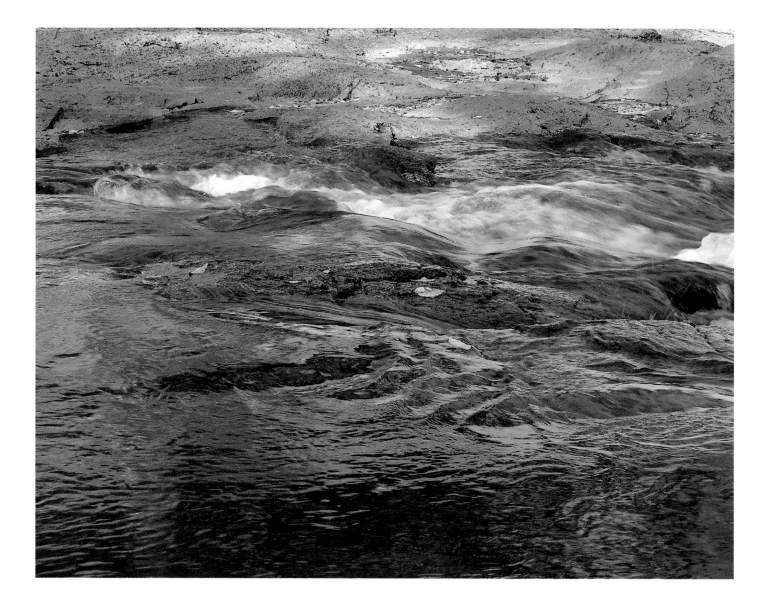

Reflections at lip of Lower Falls

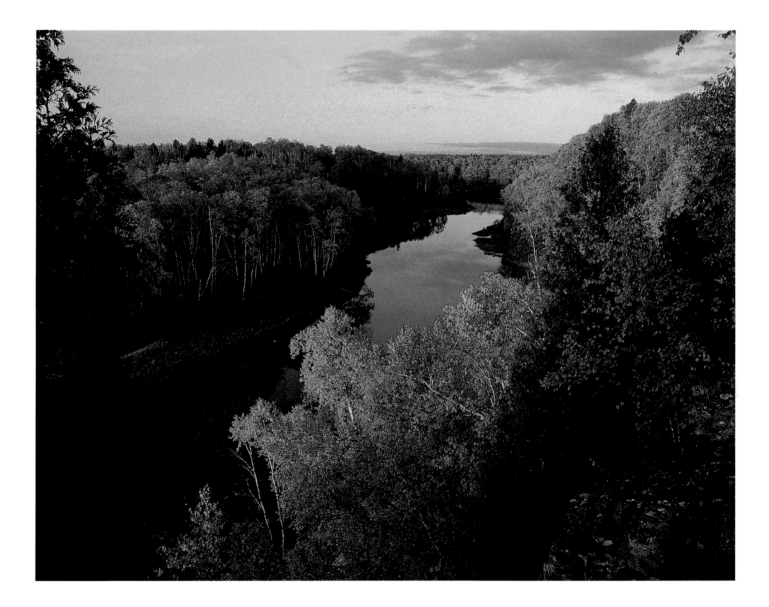

Looking upstream from near the river's mouth

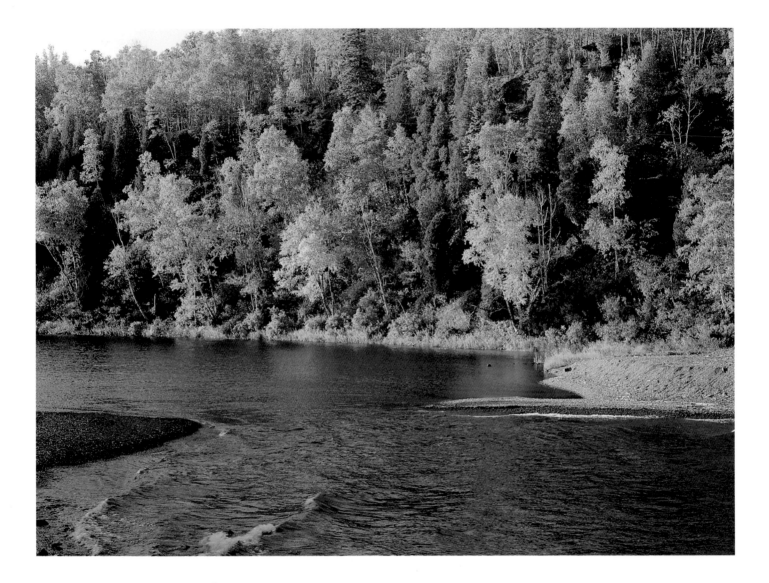

Gravel bar at mouth of the river

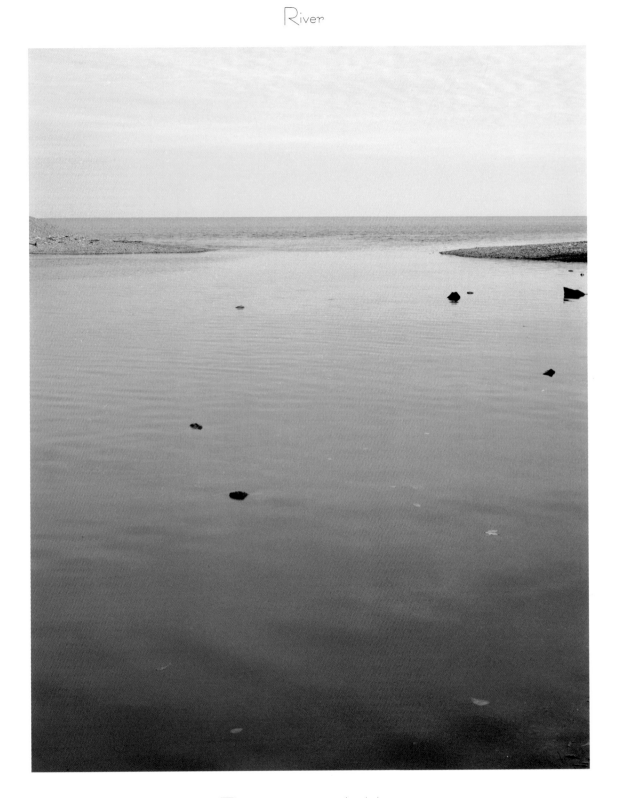

The river enters the lake

The woods of Gooseberry Falls State Park away from the waterfalls and lakeshore are the least explored feature of the park. Here you can find solitude to contemplate the larger issues of life as represented in the forest microcosms.

Neat rows of young balsams sprout on moss-covered nurse logs. Last year's deciduous leaves blend with fallen pine

# Woods

needles to form a rich, spongy humus. Bunchberries bloom where trees, now fallen, once blocked the sun. Throughout the woods life spirals up from decay.

Trees, plants, animals, and sounds fill the forest—more than you can experience in any one visit. Each hike provides a different sampling. Big-tooth aspen leaves rattle sharply in the wind, mice scratch briskly in the leaves, squirrels chatter and scold, deer blow, and ravens cry—yet nothing is as piercing as the chickadee's proclamation. From spring until fall, flowers and berries cover the forest floor; among them are Canada mayflowers, wintergreen, blue bead lily, red baneberry, white baneberry, wild roses, sarsaparilla, asters, raspberries, and thimbleberries. Ferns, mosses, fungi, and sedges also flourish beneath the trees of the park.

In autumn, when leaves shake free and fly, you can search among them for the most beautiful or the most unusual. Scoop up armloads and throw them high. Watch them float to the ground like whirligigs. Shuffle through the fallen leaves, making as much noise as you can, then sit quietly and study one branch. When will its last leaf drop?

Spend time in this intimate, sheltering place. Listen to the sounds that surround you. Look deep into the forest. The longer you gaze, the more you will see—and the more your desire to find other hidden treasures will grow.

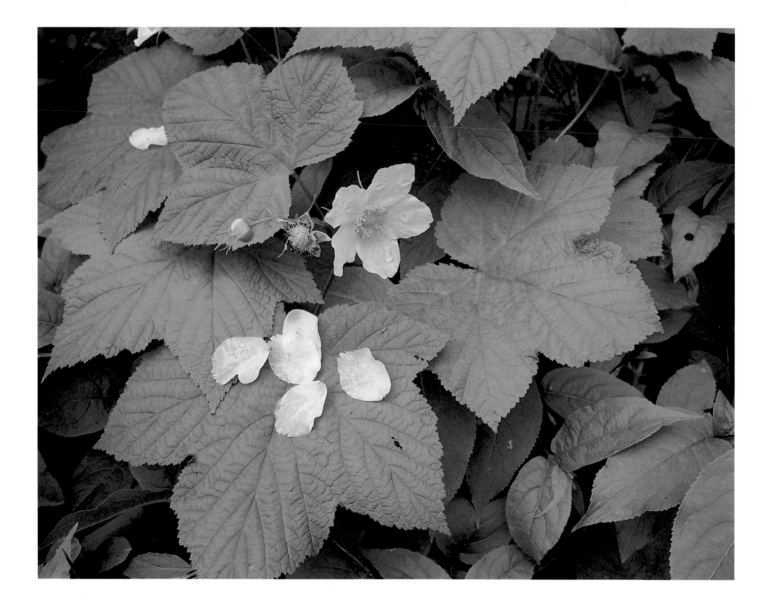

Thimbleberry blossoms

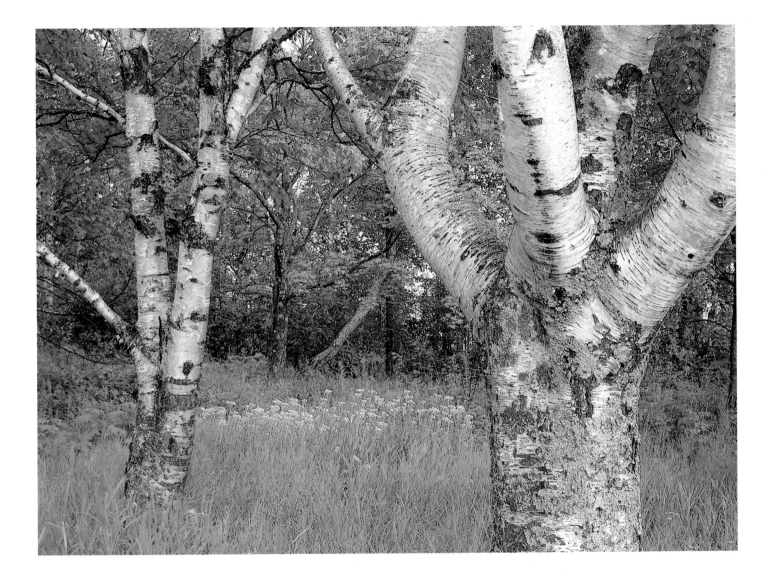

Birch trees

Gooseberry

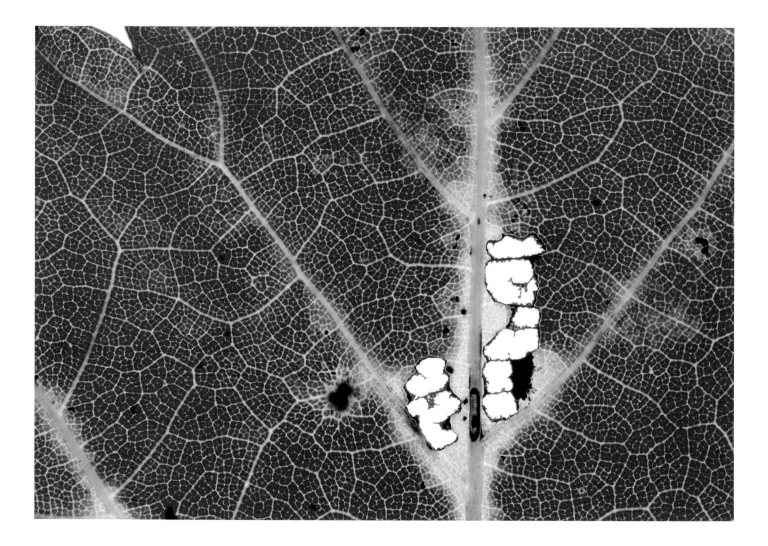

Maple leaf

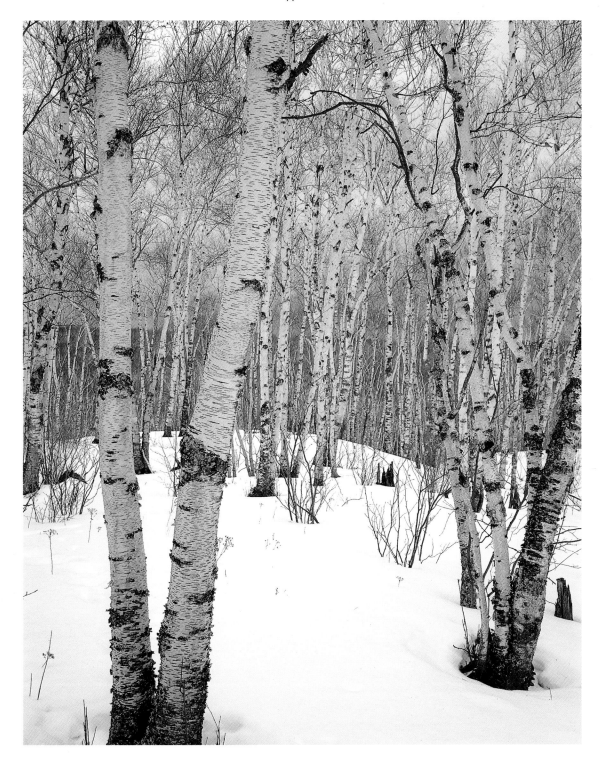

Birch forest

Gooseberry

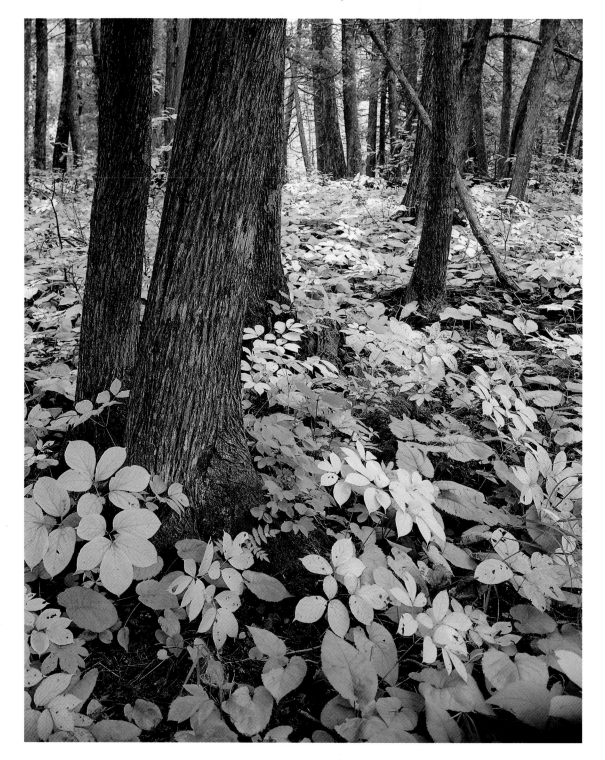

White cedar trunks

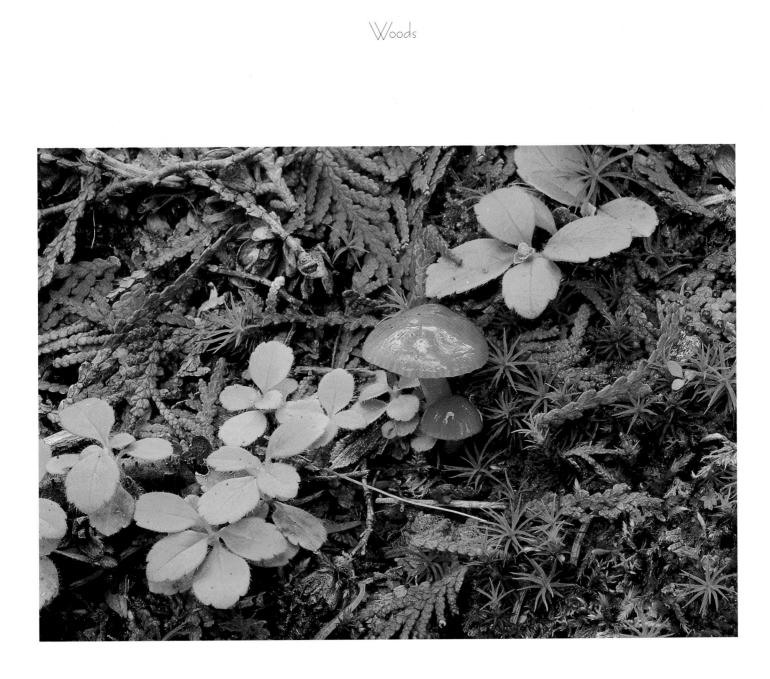

Mushrooms growing in duff beneath cedars

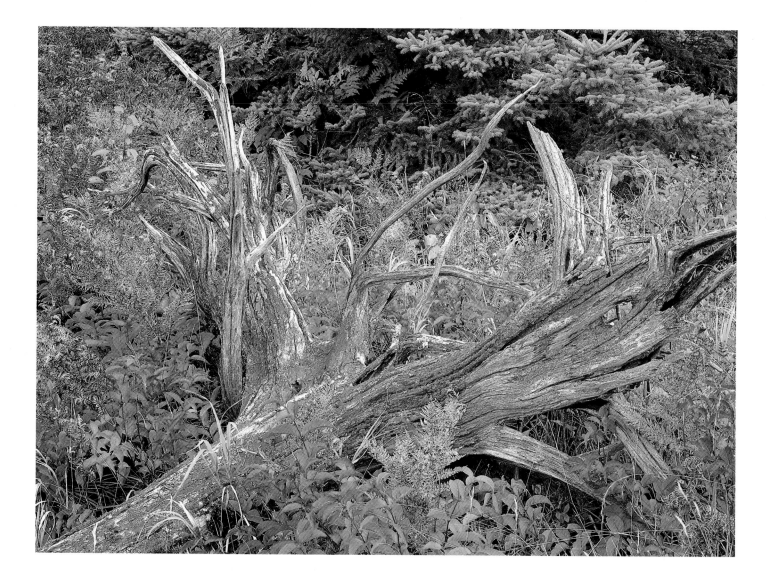

Weathered tree root and ferns

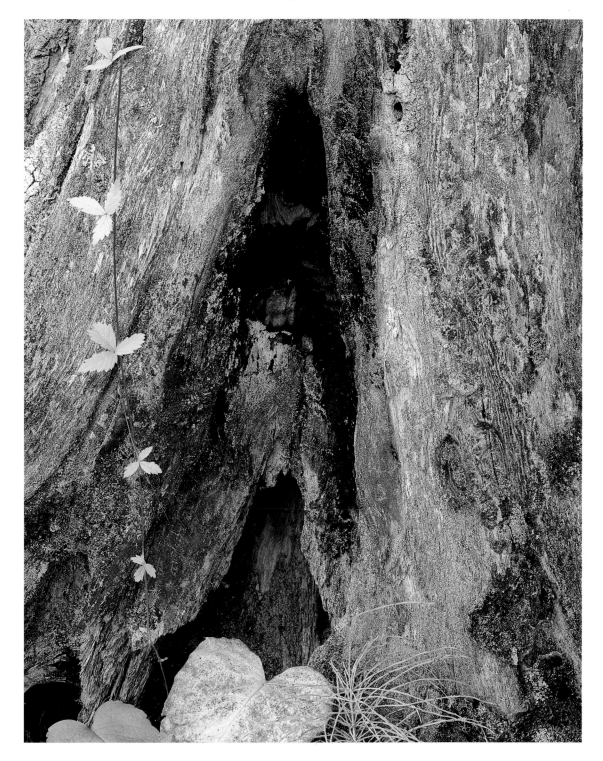

Fire-scarred stump

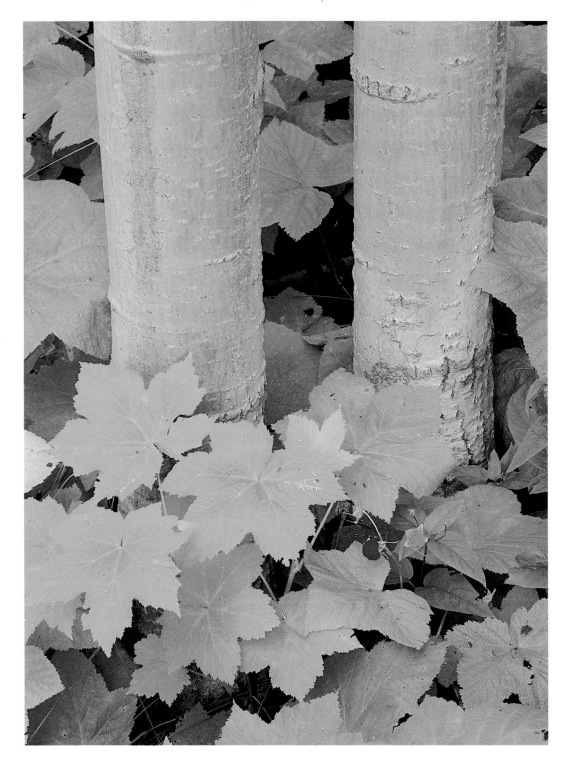

Thimbleberries and aspen trunks

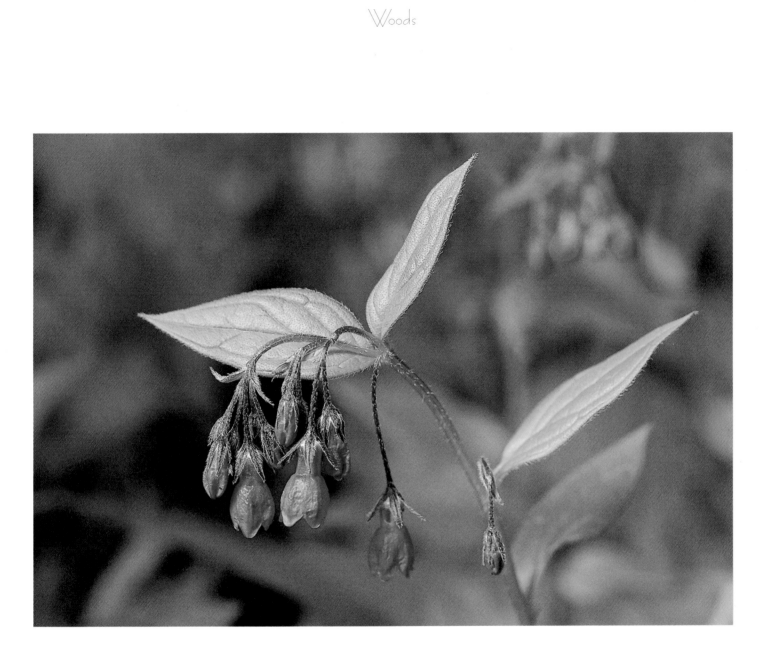

Mertensia

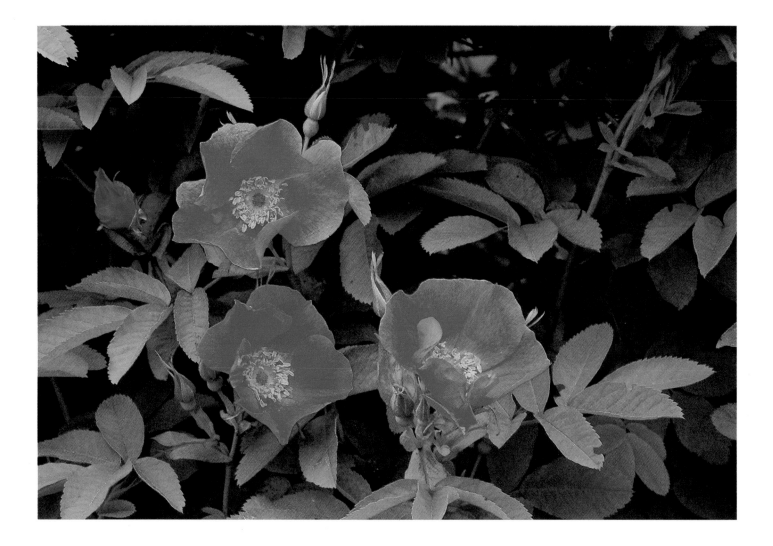

Wild roses

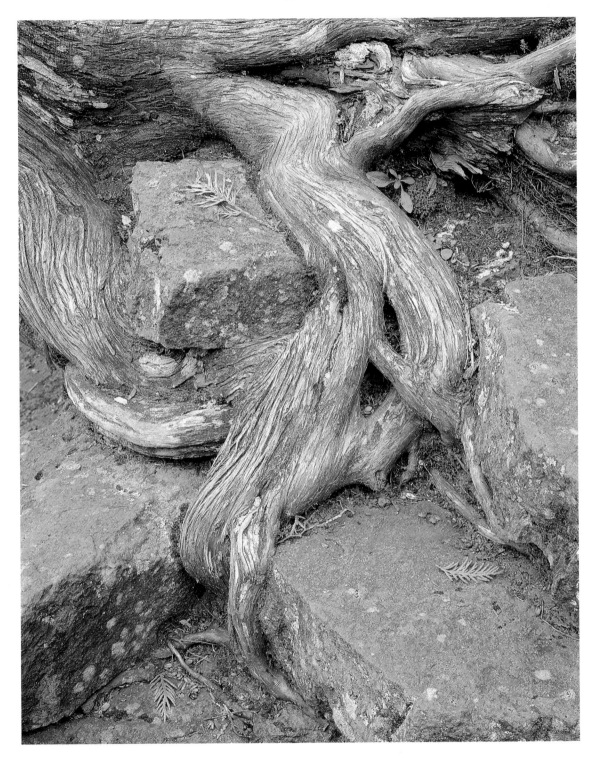

White cedar root

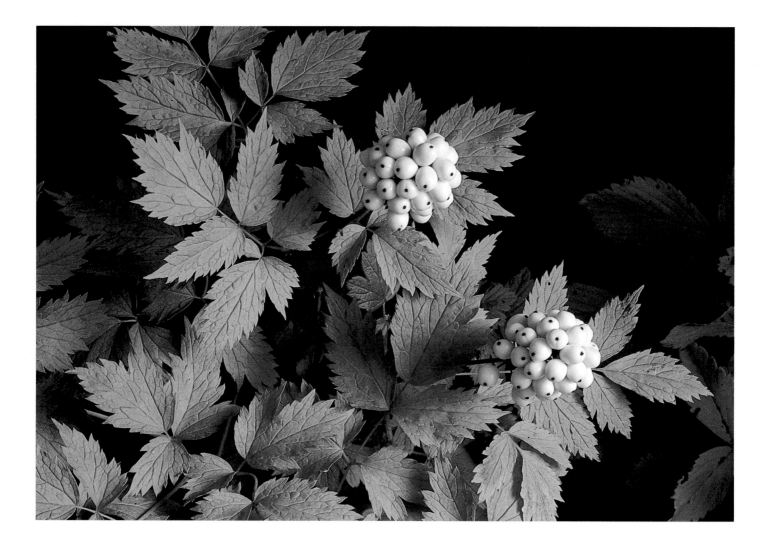

White baneberry

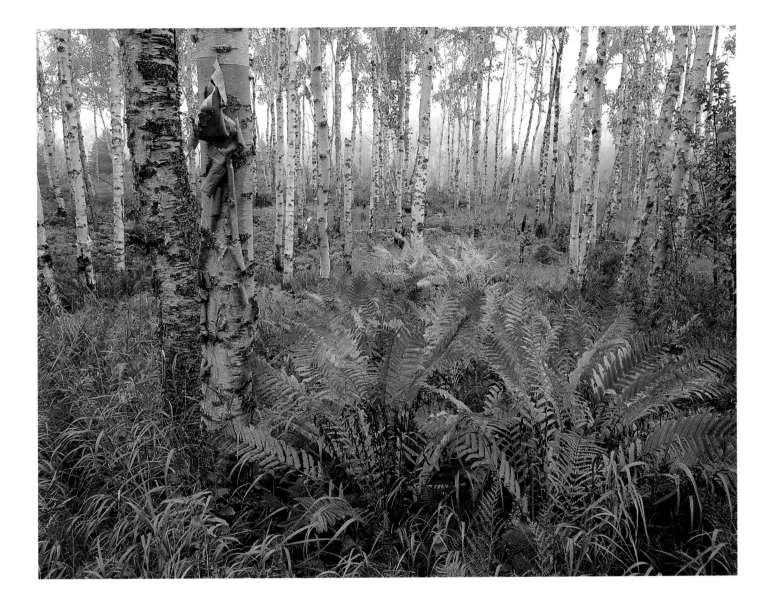

Interrupted ferns in birch forest

Gooseberry

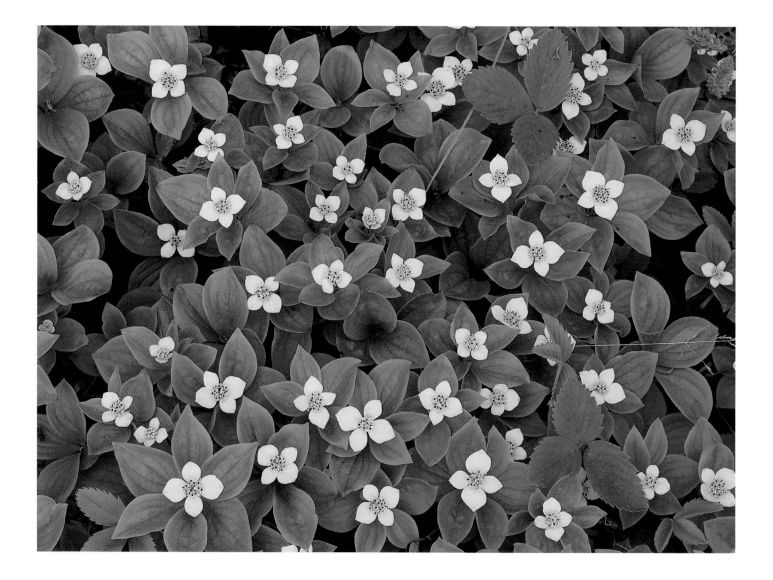

Bunchberry flowers

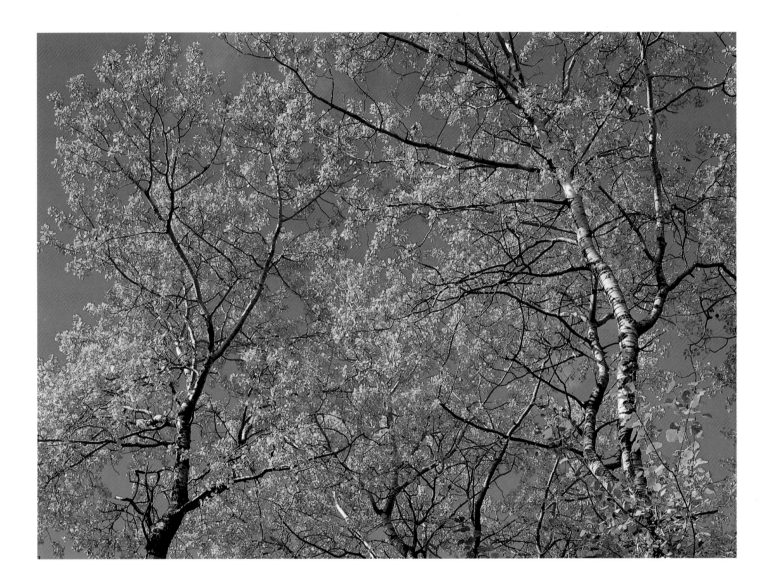

Quaking aspen

# Waterfalls

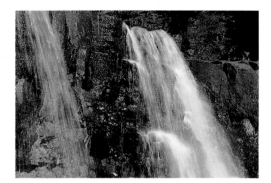

Gooseberry Falls State Park takes its name from the waterfalls on either side of the Highway 61 bridge. The Upper Falls and Lower Falls, clearly the park's biggest draw, attract thousands of people each year. On a summer's day, the nearby parking lots fill quickly and visitors swarm over the area like bees over a honeycomb.

Most visitors are content to view only the two large falls. Not many hike inland to Fifth Falls, nor do many explore the "minifalls" along the river, where tiny cascades mimic trickling water in Japanese gardens. But no matter which waterfall you visit, the magic remains the same. Watching smooth water break into a chaotic tumble can be hypnotic. Splashes and bubbles squirt out, little rainbows shimmer in the mist, and spray soaks everything within reach. At the bottom of the bigger falls, great clouds of foam build up, resembling the creamy top of a freshly-poured root beer float.

People react in different ways to the large waterfalls. The strong-willed stand right at the lip and peer over the edge, watching dark water race by to become white froth. Others stay well back behind railings on platforms, taking in a wider view of the perpetual motion and distancing themselves from the thunderous cacophony.

Everyone, though, ponders the never-ending surge and rhythm of the water as it journeys to the lake. And each of us, when we leave, takes the cadence of the falls with us. It matches our heartbeat.

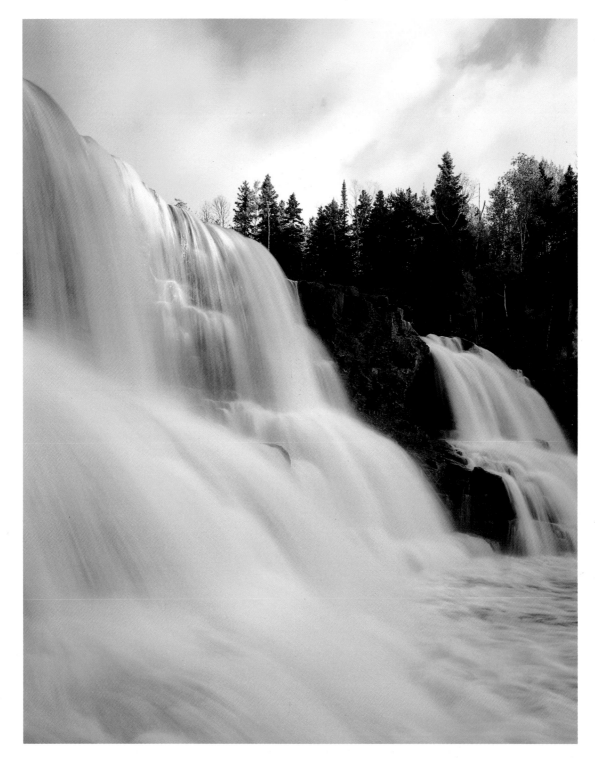

Lower Falls

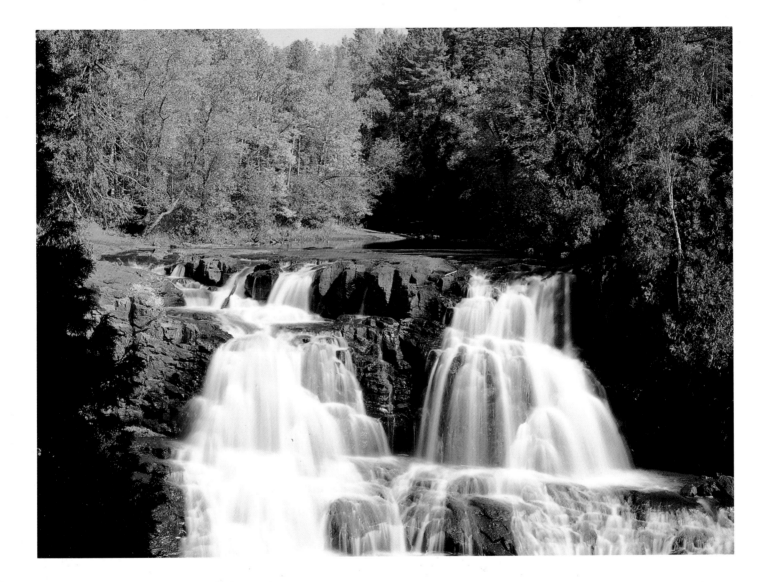

Upper Falls

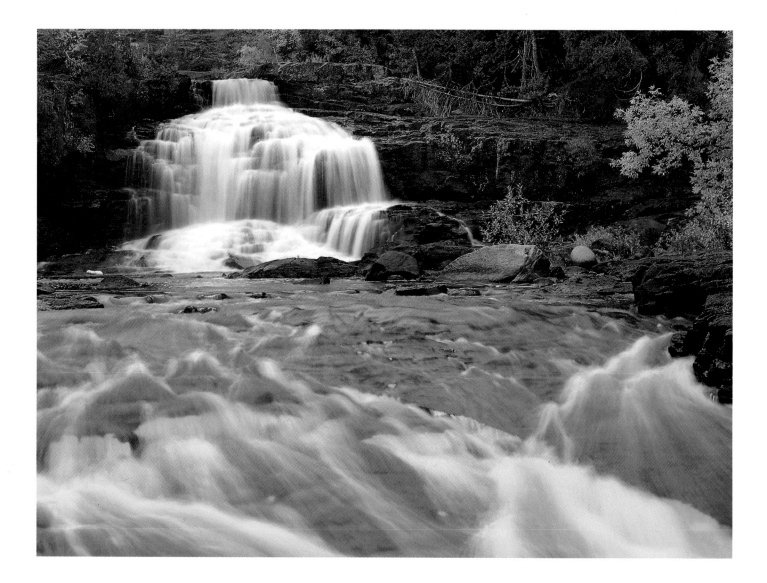

Below Lower Falls

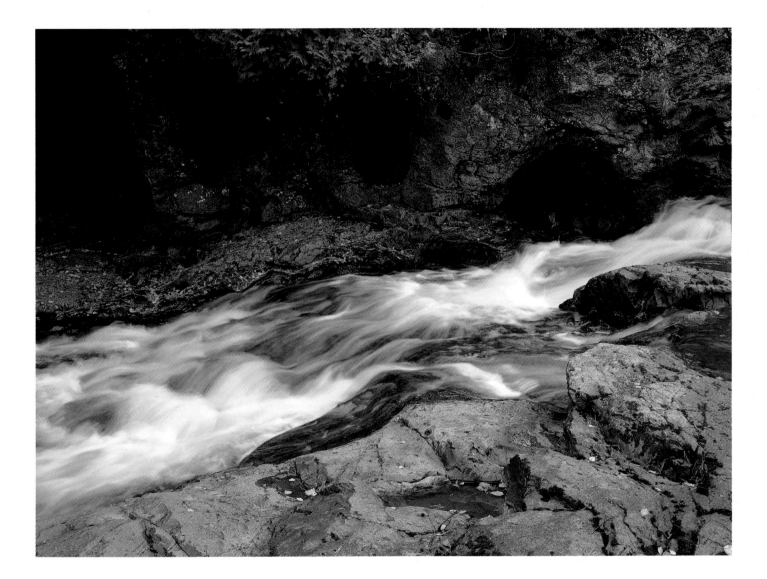

Fifth Falls

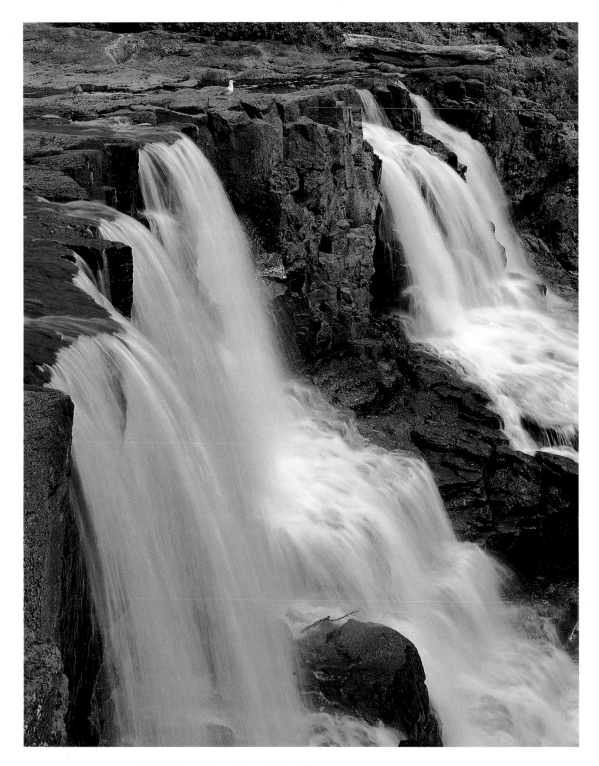

Lower Falls

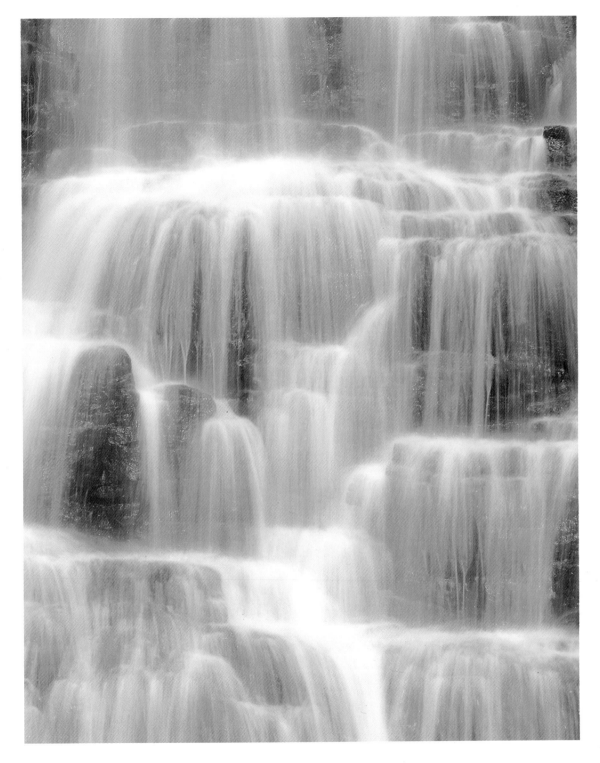

Lower Falls

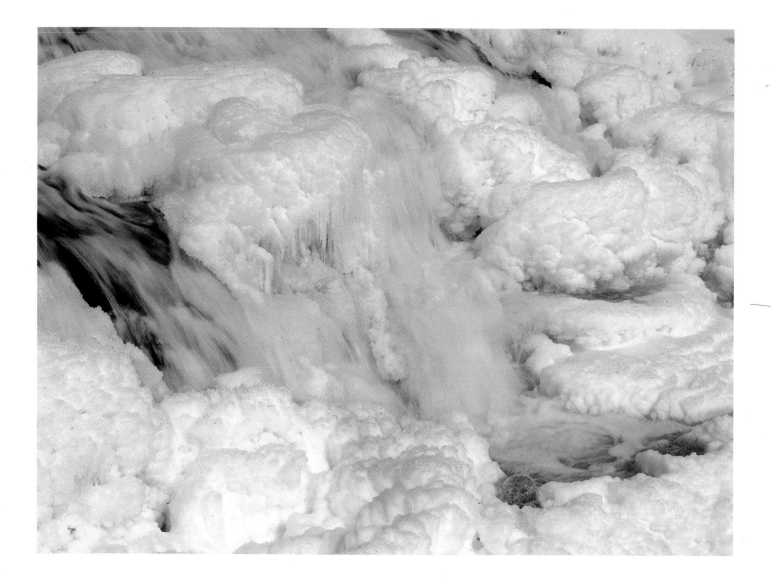

Ice, Lower Falls

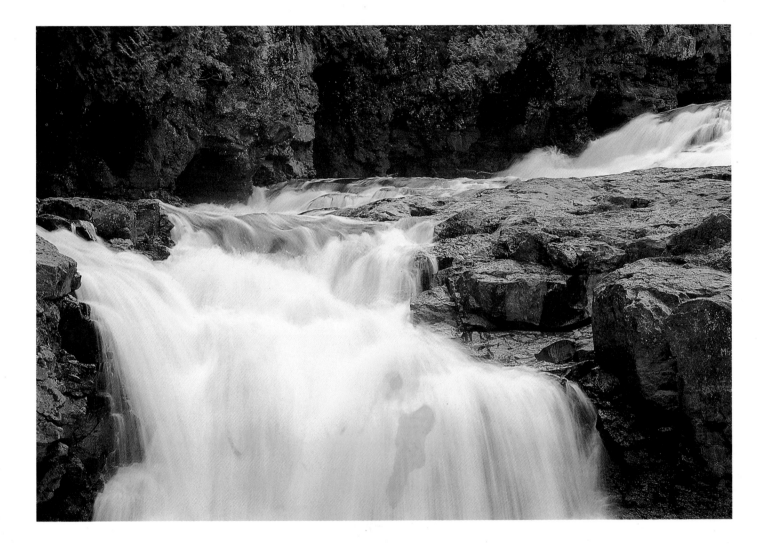

Fifth Falls

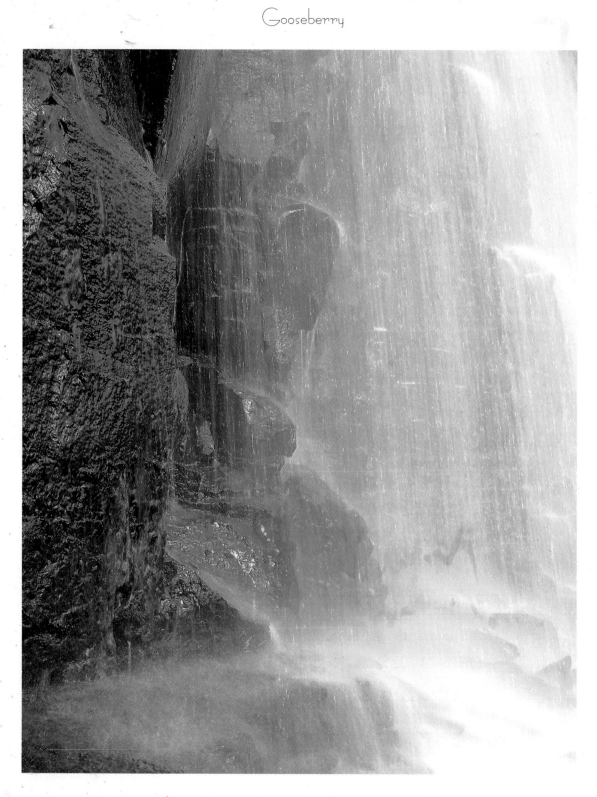

Lower Falls

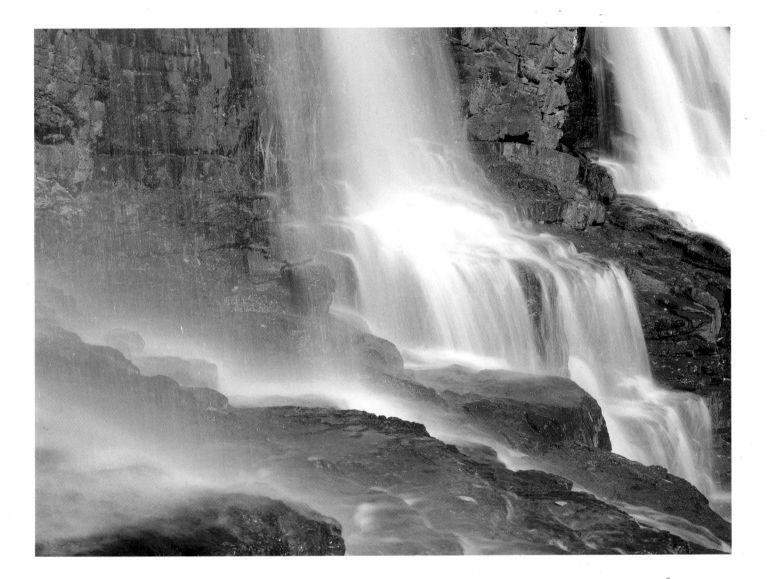

Lower Falls

Gooseberry

Ice below Lower Falls

Lip of Lower Falls

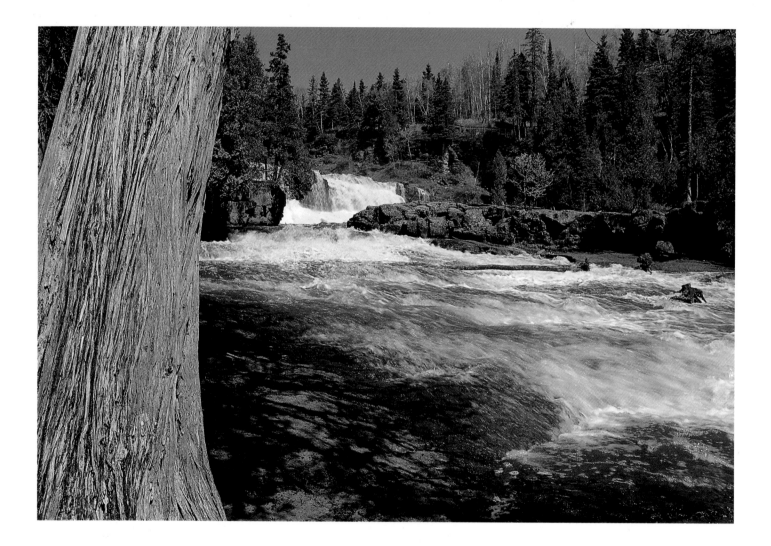

White cedar trunk and Lower Falls

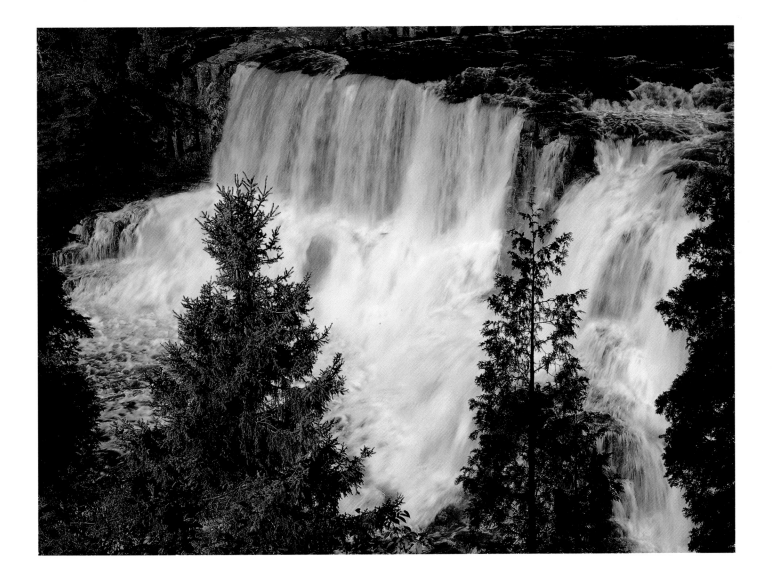

Lower Falls during high water

Approximately one-and-one-half miles of Lake Superior shoreline forms the southeastern edge of the park. Those who stand on it gaze intently into the distance, mesmerized by the vast expanse of water and sky. This massive body of water has the largest surface area of any freshwater lake in the world. Its many moods intrigue visitors. Its power is consummate.

During a raging winter storm, walls of water slam against the shore, shaking the

# Shore

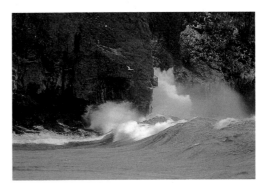

ground in a steady percussion under the whining wind. Rolling waves rival ocean breakers. The wind hurls stinging snow and freezing spray on your face. In March, off-shore winds break ice sheets apart. Giant slabs grate on each other as they pile up to mountainous heights. The keening, booming, and snapping they make is haunting and primal.

In summer, often neither the air nor the water moves. The lake shines in the sun like glass, fanciful reflections and mirages playing on and above the surface. Other summer days the lake skitters ahead of the push of cold air approaching the shore. Choppy patches mar the otherwise smooth surface, and when the waves reach shore, the temperature instantly drops.

Fog appears in many forms throughout the year—floating above the lake miles from shore after a thunderstorm; marching inland in a mammoth, dense wall, engulfing everything in its path; or delicately draping a gauzy veil over just a few trees for a brief moment after sunrise. The wide sky above Lake Superior is also a backdrop for other celestial performances. Watch a sunrise or a moonrise, a rainbow, a storm cloud, or the stars. See northern lights grow, flow, and take flight—let your mind follow.

End your visit to Gooseberry at the lake and the shore. Wade in the river's gravelly mouth or stand on a cliff and listen to the water sloshing below. Sit on a bedrock slab and dare the waves to touch you. At the shore, facing the lake, you can keep the worries of the world behind for a little longer.

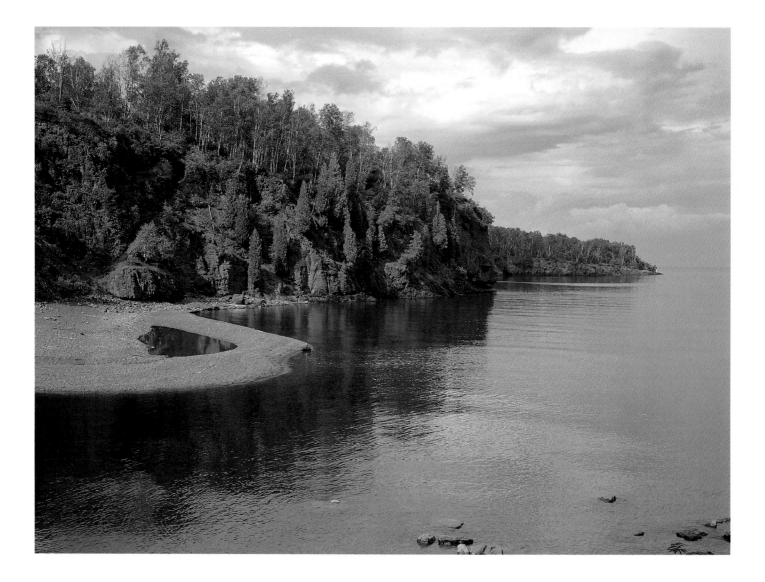

Looking northeast across mouth of Gooseberry River

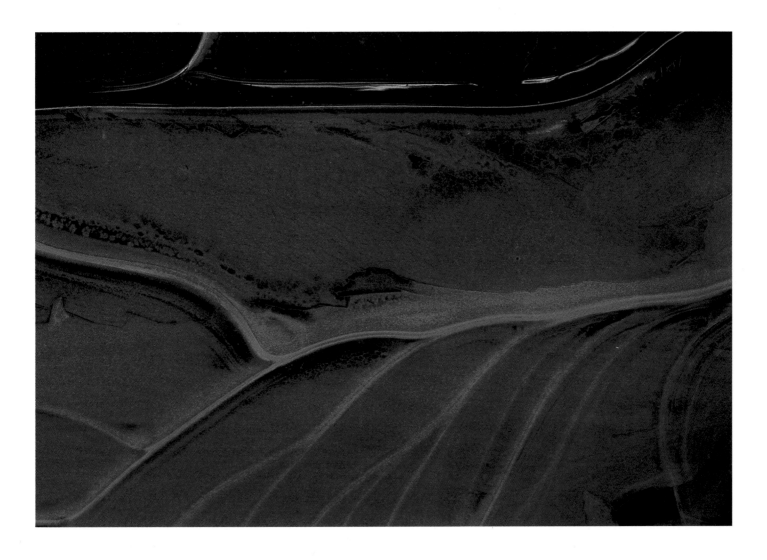

Ice in small pool

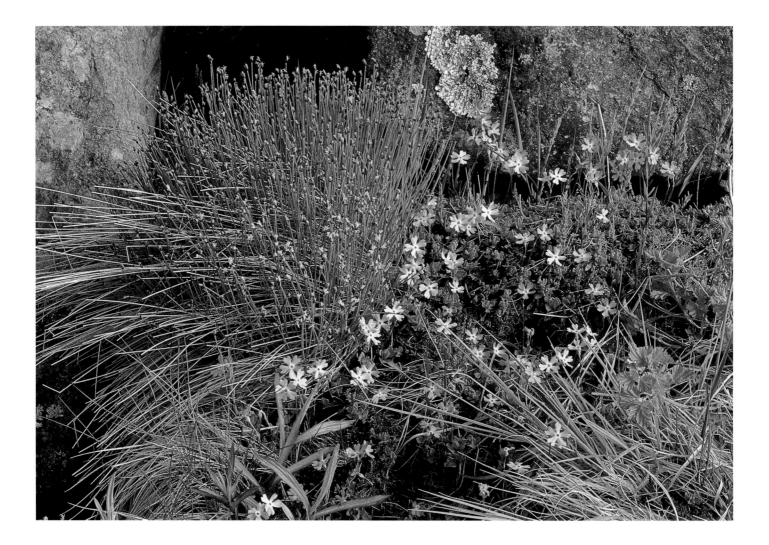

Bird's-eye primrose

Cliffs east of Gooseberry River

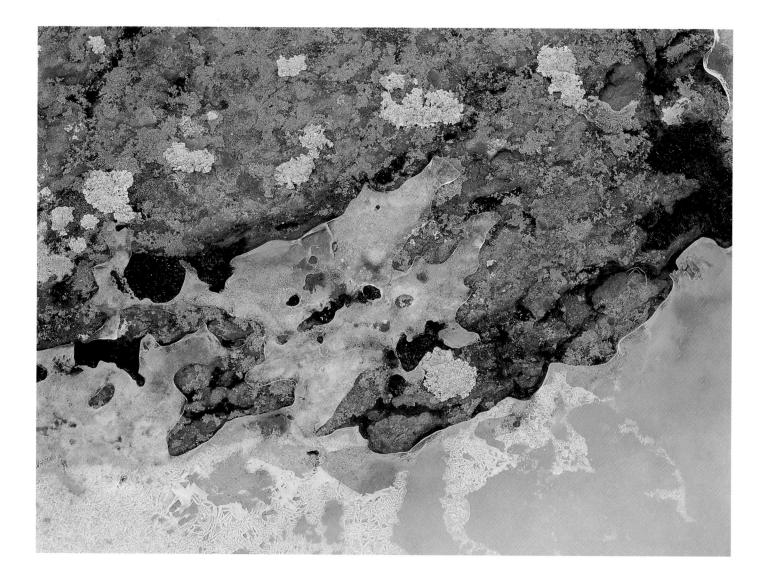

Lichens and ice

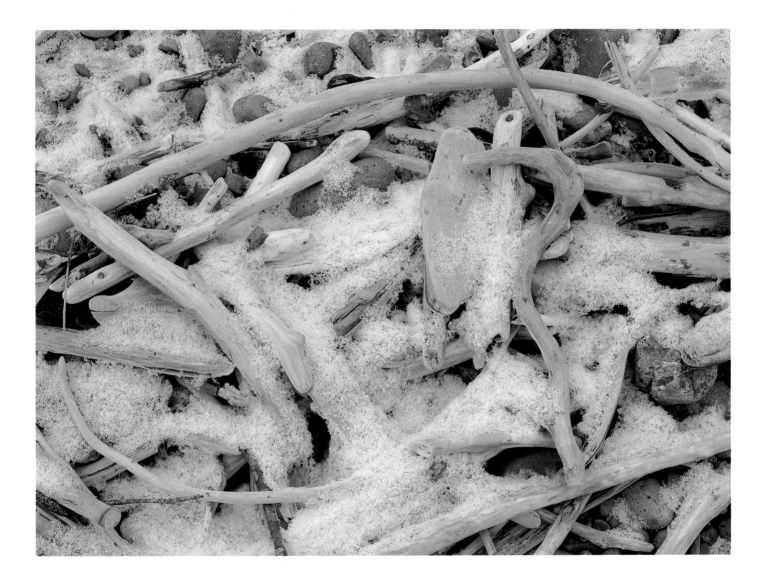

Snow-dusted driftwood

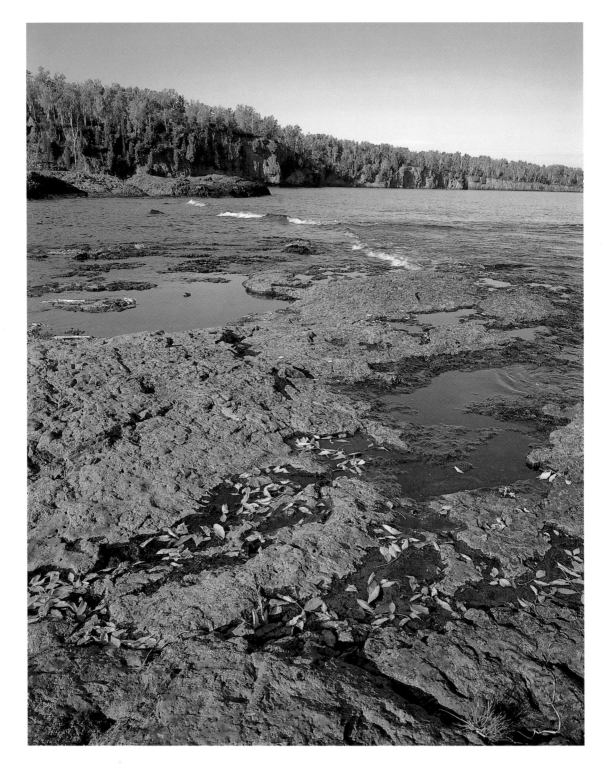

Basalt shoreline

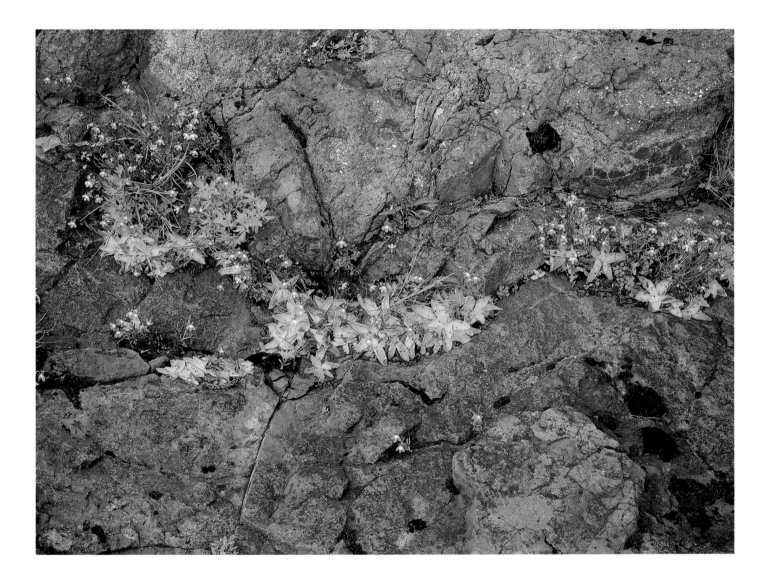

Kalm's lobelia and butterwort

Gooseberry

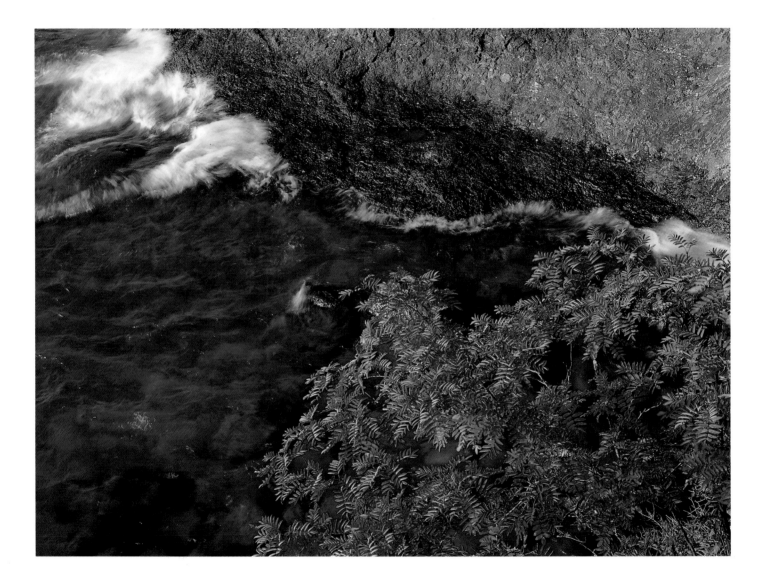

Mountain ash tree

66

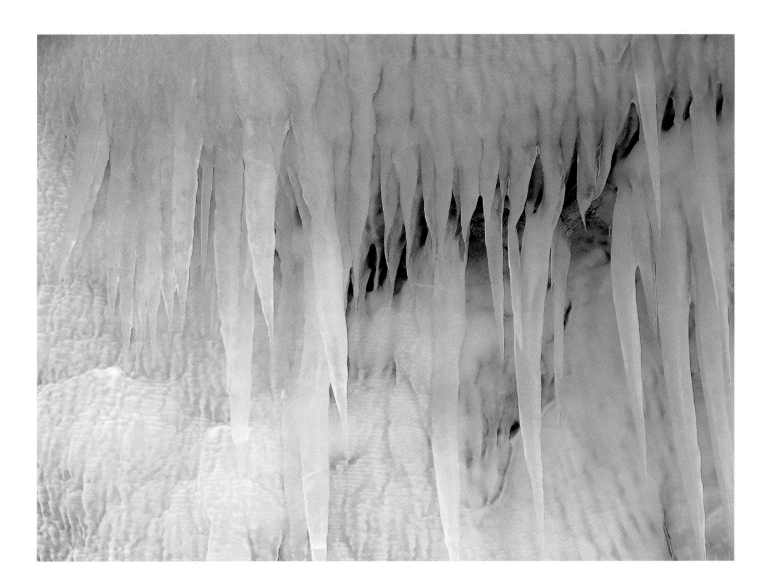

Icicles on a cliff facing the lake

Gooseberry

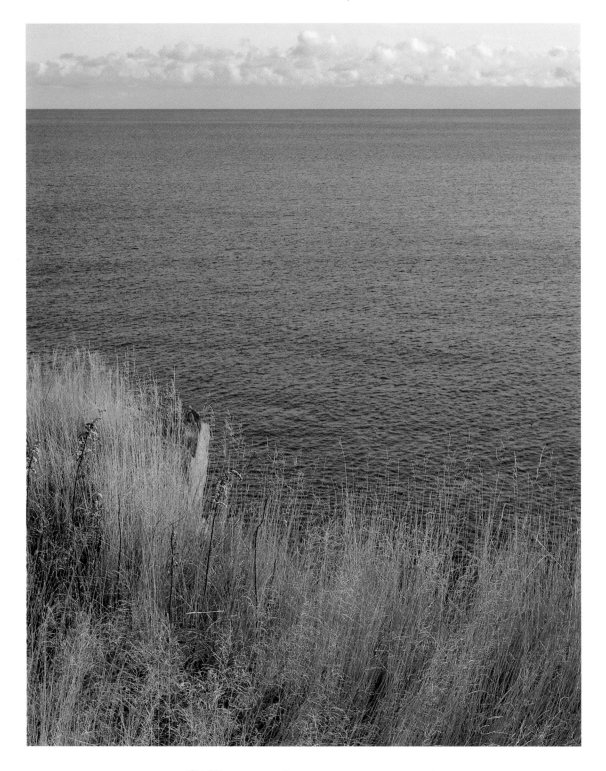

Cliff-top view from near campground

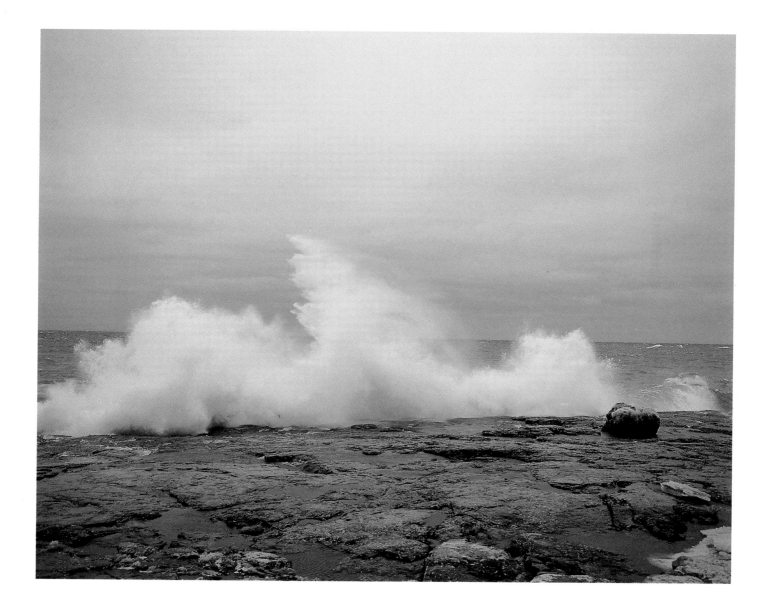

Winter storm

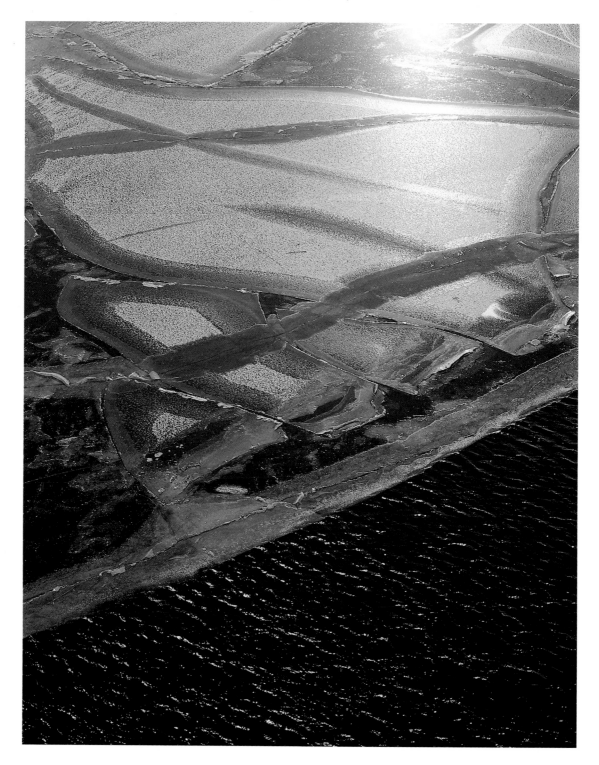

Cliff-top view of ice and open water

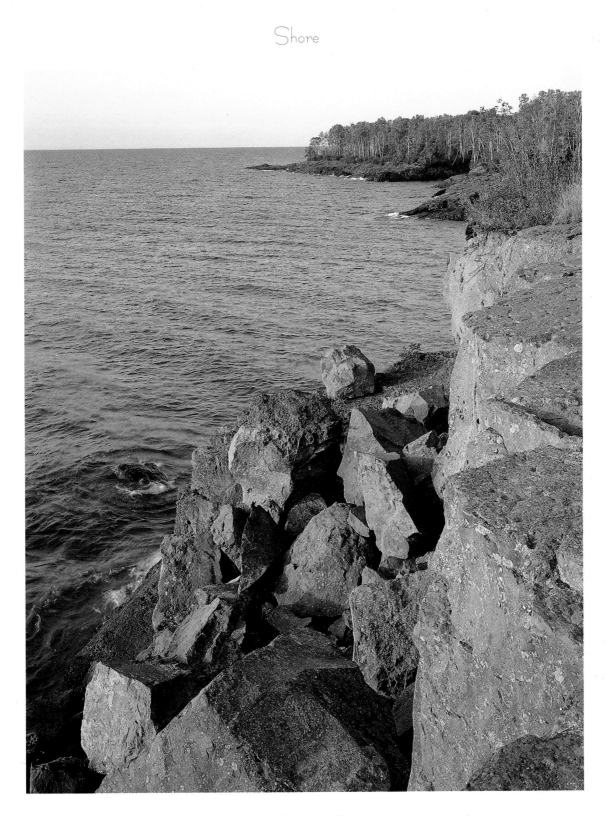

View to the southwest from cliffs near campground

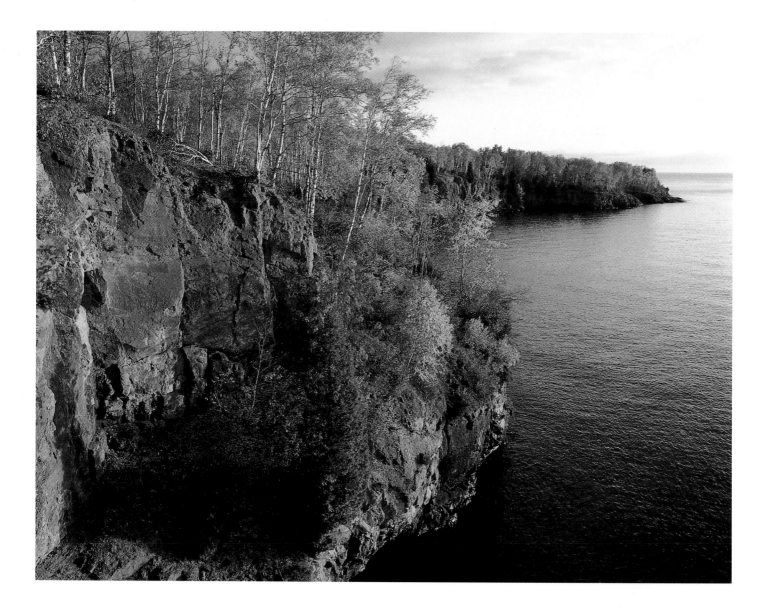

Cliffs northeast of Gooseberry River

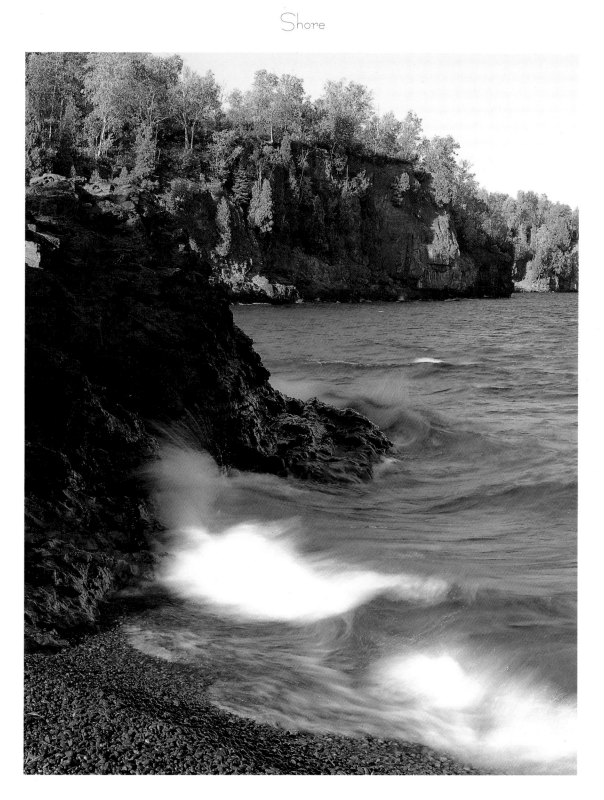

Agate Beach

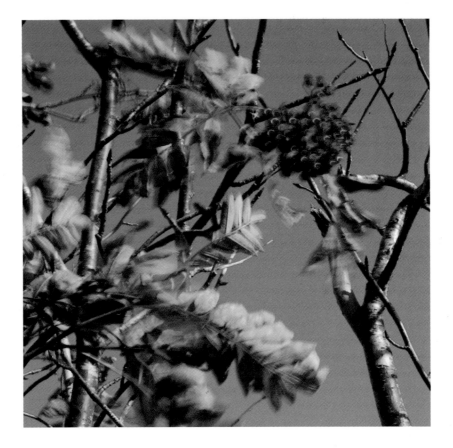

Wind-blown mountain ash berries

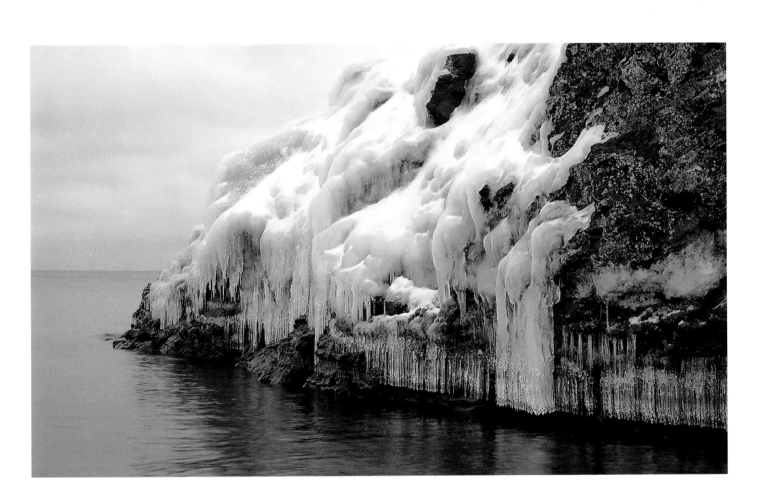

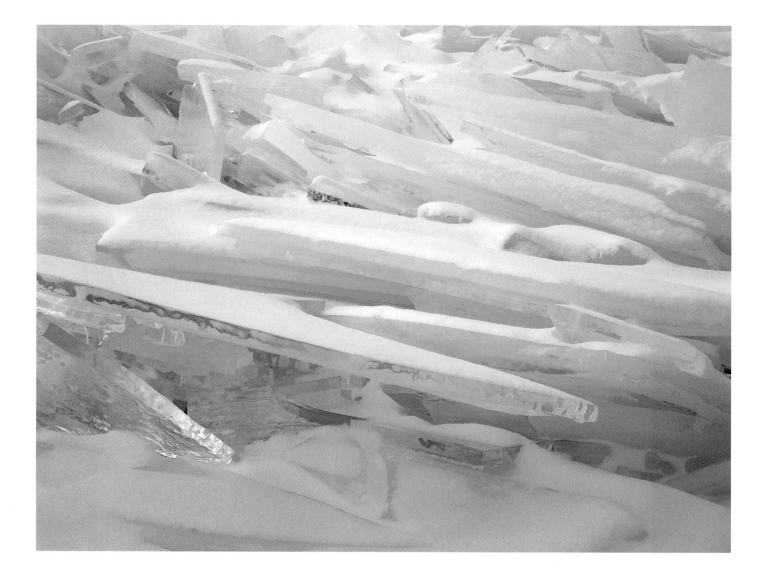

Snow-covered ice shards

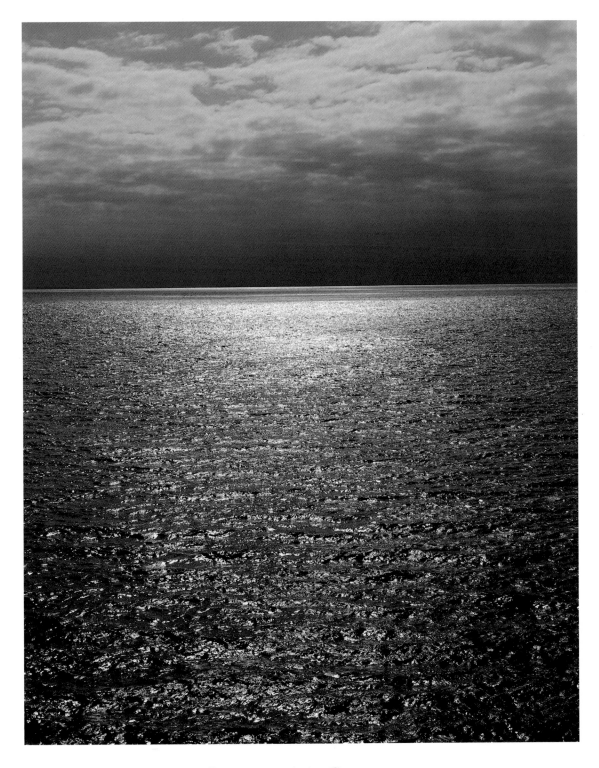

Storm over Lake Superior

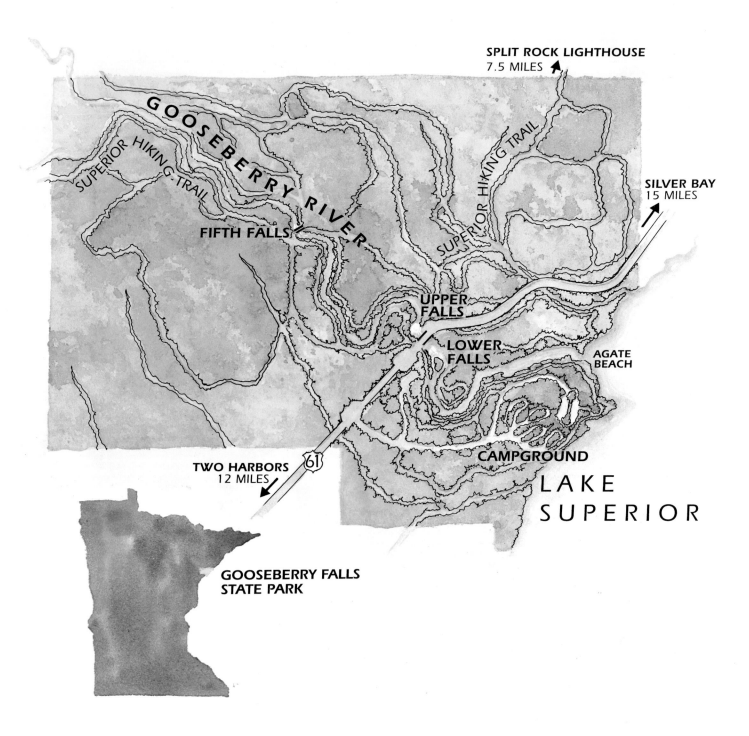

SPLIT ROCK LIGHTHOUSE
7.5 MILES

SILVER BAY
15 MILES

GOOSEBERRY RIVER

SUPERIOR HIKING TRAIL

SUPERIOR HIKING TRAIL

FIFTH FALLS

UPPER FALLS

LOWER FALLS

AGATE BEACH

CAMPGROUND

TWO HARBORS
12 MILES

61

LAKE SUPERIOR

GOOSEBERRY FALLS
STATE PARK

# About the Park

Minnesotans value the abundance of natural beauty found throughout their state, and its wealth of parks stands as an example of their attitude that this beauty must be preserved. Among those parks, none attracts more visitors than Gooseberry Falls. Approximately 750,000 people stop each year, some for a quick look at the famous waterfalls, others for a quiet hike, still others for extended camping vacations.

The history of the area reflects the state's logging heritage. The lumber industry operated near the Gooseberry River beginning in the 1890s, and some of the opened land soon became dotted with offices and railway branches. By the 1920s, harvesting and fires took nearly all of the area's red and white pines, and today the forest is primarily made up of birch, aspen, spruce, fir, and cedar.

In 1933 the state bought 638 acres from the estate of lumberman Thomas Nestor and established the park. The following year the Civilian Conservation Corps began transforming the land for park use by creating paths, campsites, and stone buildings. The structures they built are still used today, and the picnic grounds and trails they cleared remain basically unchanged.

Today, eighteen miles of hiking trails—fifteen of which double as cross-country ski trails—crisscross the park, including the Superior Hiking Trail which passes through Gooseberry inland from Highway 61. The park also boasts approximately one-and-one-half miles of Lake Superior shoreline, some of it very easy to reach from the picnic area and campgrounds.

Gooseberry's visitors delight in seeing many varieties of birds and animals that populate the park. Some, like deer, are commonly seen, but it might take a lifetime of visits to see all 142 species of birds, 10 varieties of reptiles, and 46 types of mammals.

Now expanded to 1,662 acres, the park is big enough to find solitude if you hike some of the lesser-used trails or visit during the off season. Early risers, even during summer, often find they are the only ones standing at the usually-crowded main waterfalls.

At any time, during any season, Gooseberry Falls State Park offers much to explore.